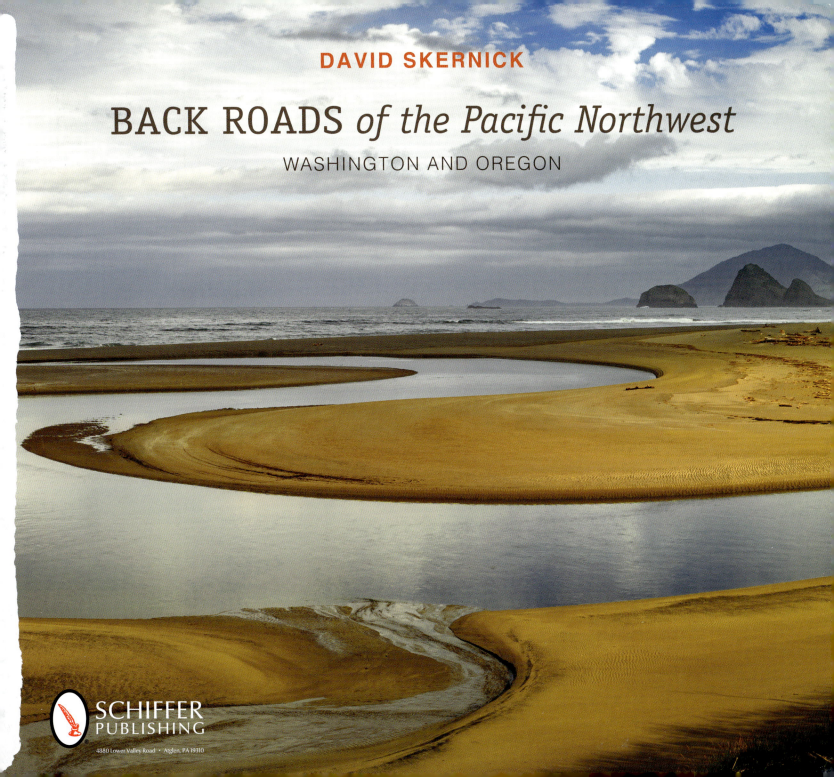

DAVID SKERNICK

BACK ROADS *of the Pacific Northwest*

WASHINGTON AND OREGON

SCHIFFER
PUBLISHING

4880 Lower Valley Road • Atglen, PA 19310

Other Schiffer Books by the Author:

Back Roads of the Southwest,
ISBN 978-0-7643-5858-6

Back Roads of Northern California,
ISBN 978-0-7643-5762-6

Back Roads of Southern California,
ISBN 978-0-7643-5763-3

Other Schiffer Books on Related Subjects:

Oregon, Barbara Tricarico,
ISBN 978-0-7643-5946-0

Oregon Coast, Barbara Tricarico,
ISBN 978-0-7643-5947-7

Type set in Proxima Nova

ISBN: 978-0-7643-6290-3

Printed in India

Published by Schiffer Publishing, Ltd.
4880 Lower Valley Road
Atglen, PA 19310
Phone: (610) 593-1777; Fax: (610) 593-2002
Email: Info@schifferbooks.com
Web: www.schifferbooks.com

For our complete selection of fine books on this and related
subjects, please visit our website at www.schifferbooks.
com. You may also write for a free catalog.

Schiffer Publishing's titles are available at special discounts
for bulk purchases for sales promotions or premiums. Special
editions, including personalized covers, corporate imprints,
and excerpts, can be created in large quantities for special
needs. For more information, contact the publisher.

We are always looking for people to write books on new
and related subjects. If you have an idea for a book, please
contact us at proposals@schifferbooks.com.

I have lots of friends from my years at Ohio University. A few have simply become family. I'd like to dedicate this book to two of them.

Kristi Templeton moved to Seattle after school. It was on a visit to see her that I first fell in love with the Pacific Northwest. I'm not saying that I wouldn't have found my way up there without Kristi, but missing her got me there sooner, and seeing it through her eyes was inspiring.

My friend Laura LiPuma joined me for a few days on my last trip to Oregon. Laura noticed how few times we stopped to photograph while together, even though I was there for that purpose, and we covered miles and miles of gray roads. I am dedicating this book to her, as well, because she brought home to me the scarcity of truly great photo opportunities and made me reappreciate the times when I was able to capture something special.

Both women have been there throughout the years to push me forward and keep me believing in myself, and, honestly, I couldn't have passed art history without their notes. I asked Kristi to write the foreword for this book because of her love of the region.

Here in the corner attic of America, two hours' drive from a rainforest, a desert, a foreign country, an empty island, a hidden fjord, a raging river, a glacier, and a volcano, is a place where the inhabitants sense they can do no better, nor do they want to.

—Timothy Egan, *The Good Rain: Across Time & Terrain in the Pacific Northwest*

FOREWORD

The ability to see the world through the lens of a camera is a wondrous thing. We get to stop time. Then we get to remember all the moments around the photograph. Getting to that place—the sounds, the smells of the landscape.

The Pacific Northwest has been my home for over three decades. When we move to a new part of the country, there is always an initial reason, but rarely do we know of all the discoveries to come: the mountains, lakes, trails to hike, parks to explore.

The Northwest has endless magic in its coastlines, for instance. On Rialto Beach, west of Forks, Washington, the stones are smooth. In the winter, when the storms are especially severe, you can hear the stones clacking when the waves are ebbing. For me, it's a song of that place. There are few people there, so you can often find yourself alone for hours. Continue north and you are at the northwest tip of the country at Cape Flattery.

East of the Cascade Mountain Range you can find plains, grassland, and orchards. The Palouse has some of the most beautiful light I've seen anywhere. The soft, buttery evening light and rolling hills are images that I think of again and again.

We have tulip fields that rival anything you can find in Holland, and lavender farms as beautiful as anything in the South of France. The natural beauty includes two mountain ranges, lakes, old-growth forests, a rainforest, and native lands.

When I travel, my goal is to become a local, to blend in, to get lost. To see through the eyes of a child, where everything is new and possible.

I believe David Skernick's greatest strength is his curiosity and wonder. When we wander, we want to see new things—we want to be astonished. David provides that. He does the searching for us. The perfect light, angle, moment. He takes the back road to a place we don't take the time to see. We know these places, often, but not from that particular angle or that time of day. He'll wait for hours for the perfect shot.

I believe David would agree with John Muir when he said, "The world is big and I want to have a good look at it before it gets dark."

—Kristi Templeton

ACKNOWLEDGMENTS

As I sit down to write this acknowledgment, the usual faces swim in front of me. My wife, my friends, my students, and even the dogs that greet me when I come home are all responsible for the success of these books. Both this book and the Great Plains book were finished during the last two years or so. During that time, I said goodbye to one truck and hello to a new one. Bob 3 was a loyal Ford F/150. The four-wheel-drive option got me through rivers, swamps, mud, and snow more times than I can count. You will see "him" several times on the following pages. At 300,000 miles, I gave him up before I might find myself lost and in trouble on one of those gray roads I love so well. So yeah, I'm acknowledging a truck. Bob 3 saved my life by keeping me safe from the elements and wildlife, got me to loads of gray roads, and took me home over and over again.

Thanks Bob 3—rest well.

Saying goodbye to Bob 3 . . . Bob goes to the beach. Quinault Indian Reservation.

INTRODUCTION

This book is part of a series of books of photographs taken all over the United States—a collection of places and things I see as I drive along. I travel 50,000 miles or so every year along the back roads of the United States. I call this getting lost on gray roads. On the maps you can get at your local AAA office, gray is the color of the smaller, two-lane winding roads.

Being lost is not about losing one's way, but rather the utter pleasure of being nowhere specific. Gray roads ramble across the landscape as if they have only a vague idea where they are going, hunting for clues of cardinality in small towns and railroad crossings.

I'd like to walk the Pacific Northwest . . . nope, not actually gonna do it. I'm sixty-four years old, overweight, and mostly lazy, but I'd *like* to do it. Why? It just seems like there's a photo about to happen every 10 feet or so.

It rains a lot in the Pacific Northwest. No, really—it rains a lot! All that rain is why it is so amazing: everything is soaked and lush and green! Stormy weather means clouds and fog too. When you have great—no, spectacular—clouds, you are one-third into a terrific photograph before you even set up the camera. Then it becomes a race to find foreground and midground.

Oregon and Washington are like huge terrariums! Everywhere you look, stuff is growing. There is over 500 miles of pristine coastline, close to thirty lighthouses, seven national parks, and a ridiculous number of waterfalls, tulip fields, and quaint little towns where you just want to stop and hang out for a while.

It was hard to put this book into any meaningful order. I like to make you feel like you're going from point A to point Z in my books. This time, you're sort of driving in circles, because that's what I do when I'm in Oregon and Washington. I've spent time up there during several different seasons and been through all kinds of weather conditions. You'll see what I mean. I separated Oregon and Washington just so you'd have some idea of where you are. If you're up for a road trip, grab a raincoat and let's go!

Photo by Jackie Rosenthal

Coquille River Light, Oregon

Yaquina Head Light, Oregon

Meyers Creek Beach, Oregon

I used a six-stop neutral-density filter to slow the water and clouds.

Cape Blanco Light, Oregon

Rainstorm, Oregon coast

Train crossing, Elgin, Oregon

Prehistoric Gardens and Bob 3, Oregon

Rainbow over Summer Lake, Oregon

Crater Lake National Park, Oregon

Mount Hood from Tony Mohr Drive, Oregon

Barn and fog, Indigo Street NE, Oregon

I had to wait twenty minutes for the fog to lift enough to reveal the barn.

Full apple crates on Fir Mountain Road, Oregon

I stood on Bob the Truck to get this angle. A farmer watching me just shook his head.

Honor pumpkin stand, Silverton Road, Oregon

Multnomah Falls, Columbia Gorge National Scenic Area, Oregon

Mount Adams from Dethman Ridge Drive, Oregon

Columbia River Inlet at Rooster Rock, Oregon

Bridal Veil Falls, Columbia Gorge National Scenic Area, Oregon

Oregon Historic Route 30, from Rowina Overlook

This road is every bit as fun to drive as it looks!

Ground squirrel, Oregon

Honeybees, Fruit Loop, Oregon

Tree frog, Oregon

Old Highway 30, Columbia River Gorge

Pheasant, Oregon

Middle North Falls, Silver Falls State Park, Oregon

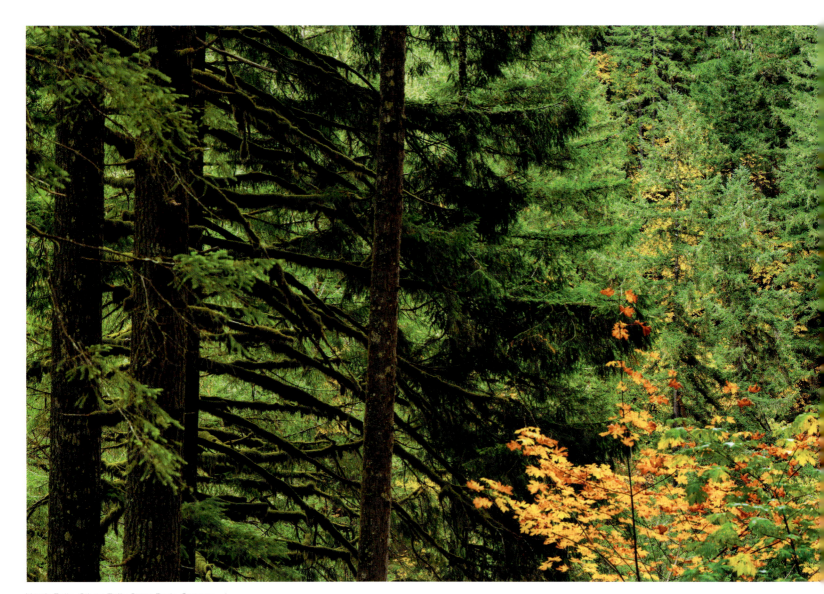

North Falls, Silver Falls State Park, Oregon

National Forest Road 13, Mount Hood National Forest, Oregon

I was lost when I came across this road. I love getting lost!

Hawk, Oregon

Rasmussen Farm, O'Dell, Oregon

Mark O. Hartfield Wilderness, Oregon

Osprey, Oregon

Jackrabbit, Ankeny National Wildlife Refuge, Oregon

Railroad tracks near Eddyville, Oregon

A minute later I was scrambling down the side to get away from a train.

White field and barn, Howell Price Road, Oregon

Coria Estates Vineyards, Oregon

Wooden Shoe Tulip Farm, Oregon

It was raining and I got stuck in the mud a couple of times, but I think it was worth it.

Painted Hills, John Day Fossil Beds National Monument, Oregon

The light hit this scene just long enough for me to make the shot. Lucky!

Blue Mountain Crest, Oregon

Trout meadow, Oregon

North Fork Wilderness from Blue Mountain, Oregon

Barn and horses along Oregon State Highway 203

Farm on Williams Road, Wilbur, Washington

Lone tree on Yellow Dog Road

Mustard field, Bob Schultz Road, Washington

Thanks, Bob Schultz, for inviting me and the photo workshop to photograph your property.

Wind farm along Washington State Highway 12

Silos along Washington State Highway 28

Infrared

Fence off Hay Road, Washington

Wayne and Linda's barn, Palouse Hills, Washington

Tractor along Washington State Highway 23

Hills along Getz–AE Seavers Road, Washington

Hoffman Road farm, Palouse Hills, Washington

Canola farm near Albion, Washington

Trees and hills near Elberton, Washington

Palouse Falls State Park, Washington

Cloud and wheat field, Seavers Road, Palouse Hills, Washington

Garfield County, Washington

Hello, horse! Washington State Highway 23.

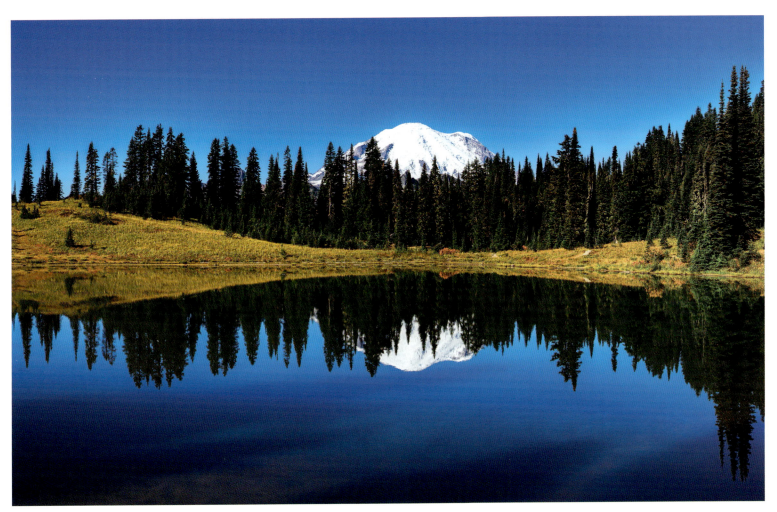

Tipsoo Lake, Mount Rainier National Park, Washington

Toledo, Washington, and Bob 3

Ohawapecosh River, Mount Rainier National Park, Washington

Juvenile bald eagle, Washington

Mount Rainier from Paradise, Washington

The road ended here for the season. The snow was about 10 feet high. I had to climb on top to take this panorama.

Tunnel on Washington State Highway 123

Laughing Water Creek, Mount Rainier National Park, Washington

Diablo Dam, Washington

Giant leaves along Washington State Highway 410

Canada jays, Mount Rainier National Park, Washington

Elk, Goat Rocks Wilderness, Washington

Snoqualmie Pass, Washington

Olsen Bluff along Coulee Meadows Road, Washington

Lake Chelan with apple orchards

Apple orchard along Washington State Highway 17

These were honeycrisp apples—the best!

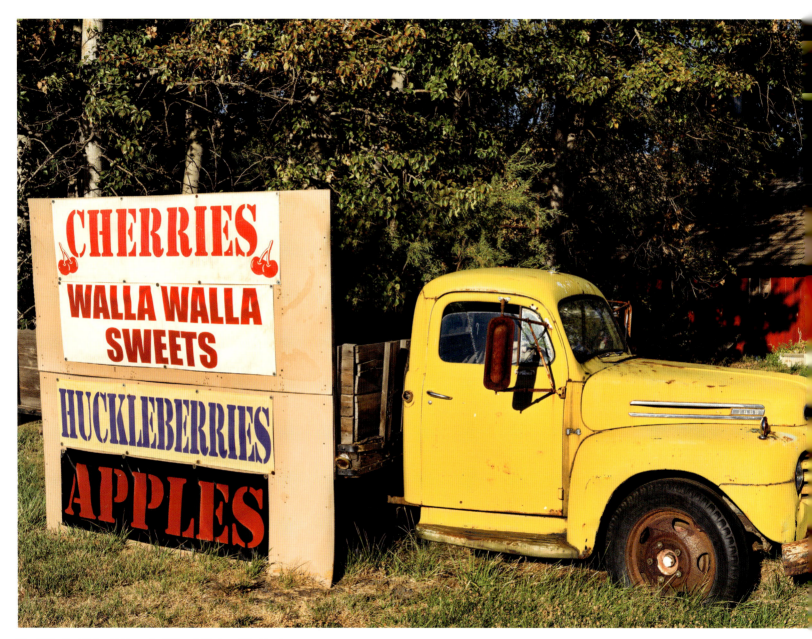

The Little Red School House Fruit Stand, Naches, Washington

I always try to buy something from businesses I photograph, just to be nice. I got some pears here that were amazing!

Apple crates on LaGrange Road, Washington

I've never seen crates piled this high. They went up more than 30 feet.

Apple orchard along Columbia River, Washington

Snow geese, Washington

Snow geese near Wickersham, Washington

Snake River, Washington

Mineral Train Museum, Washington

Mineral Lake, Washington

Old schoolhouse, Road J SE, Waterville, Washington

Fish Lake, Washington

Best Road, Skagit Valley, Washington

The wind was blowing so hard, I had to lean against Bob the Truck and use a superfast shutter speed.

Tulips, Calhoun Road, Skagit Valley, Washington

All the hype about "golden hour" is sometimes true.

Barn along Washington State Highway 536

Tulip field near Mossyrock, Washington

Ruby Beach, Washington

Mayer Farms, Washington

Sunset, Deception Pass, Washington

Cape Disappointment North Head Light, Washington

Neah Bay Harbor, Washington

La Push Harbor at First Beach, Washington

Westport, Washington

Elephant seal, Olympic Coast National Marine Sanctuary, Washington

Port Angeles, the *Orient Hope*

How does this thing float?

Fort Casey Light, Washington

Nisika Beach, Oregon

Latourell Falls, Columbia Gorge National Scenic Area, Oregon

Wild turkey, Oregon

North Camp Ground Trail, Silver Falls State Park, Oregon

I hiked this trail. It was wonderfully peaceful.

Mount Hood and Trillium Lake, Oregon

View from Sunrise Road at 6,100 feet, Mount Rainier National Park, Washington

Mount Baker, Washington

Lake Quinault, Washington

This scene was a complete surprise as I came around a corner. The lake wasn't even on my map.

APPENDIX

Page	Image Name	Camera	Lens	F/Stop	Shutter Speed	ISO	Pano Image Count	Pano Levels	Dimensions in Inches
8	Coquille River Light, Oregon	Nikon D750	Nikkor 50mm f/1.4	f/11	1/100	100	20	4	31x48
9	Yaquina Head Light, Oregon	Nikon D750	Nikkor 50mm f/1.4	f/11	1/125	100	8	1	54x31
10	Meyers Creek Beach, Oregon	Nikon D750	Nikkor 85mm f/1.8	f/11	15"	100	22	2	96x36
12	Cape Blanco Light, Oregon	Nikon D750	Nikkor 50mm f/1.4	f/11	1/125	100	10	1	48x15
14	Rainstorm, Oregon coast	Nikon D750	Nikkor 85mm f/1.8	f/11	1/100	100	14	2	96x28
16	Train crossing, Elgin, Oregon	Nikon D750	Nikkor 35mm f/1.4	f/11	1/160	100	5	1	48x40
17	Prehistoric Gardens and Bob 3, Oregon	Nikon D750	Nikkor 50mm f/1.4	f/11	1/20	100	10	1	54x26
18	Rainbow over Summer Lake, Oregon	Nikon D2X	Nikkor 12–24mm f/4.0	f/8	1/320	100	n/a	n/a	24x16
19	Crater Lake National Park, Oregon	Nikon D750	Nikkor 35mm f/1.4	f/11	1/200	100	6	1	48x30
20	Mount Hood from Tony Mohr Drive, Oregon	Nikon D810	Nikkor 85mm f/1.8	f/10	1/160	64	5	1	75x36
22	Barn and fog, Indigo Street NE, Oregon	Nikon D810	Nikkor 50mm f/1.4	f/11	1/15	64	20	2	51x24
24	Full apple crates on Fir Mountain Road, Oregon	Nikon D810	Nikkor 85mm f/1.8	f/13	1/80	64	25	3	90x32
26	Honor pumpkin stand, Silverton Road, Oregon	Nikon D810	Nikkor 50mm f/1.4	f/11	1/25	64	7	1	95x39
28	Multnomah Falls, Columbia Gorge National Scenic Area, Oregon	Nikon D800E	Nikkor 85mm f/1.8	f/14	1/25	100	7	1	48x19
30	Mount Adams from Dethman Ridge Drive, Oregon	Nikon D800E	Zeiss 135mm f/2.0	f/14	1/125	100	5	1	48x28
31	Columbia River Inlet at Rooster Rock, Oregon	Nikon D810	Nikkor 50mm f/1.4	f/14	1/13	64	18	2	98x62
32	Bridal Veil Falls, Columbia Gorge National Scenic Area, Oregon	Sony A7RII	Sony 55mm f/1.8	f/14	5"	64	20	2	124x54
34	Oregon Historic Route 30, from Rowina Overlook	Sony A7RII	Sony 55mm f/1.8	f/11	1/160	64	21	2	120x40
36	Ground squirrel, Oregon	Nikon D500	Nikkor 200–500mm f/5.6	f/9	1/1600	11400	n/a	n/a	16x24

37	Honeybees, Fruit Loop, Oregon	Nikon D7100	Nikkor 70–200mm f/2.8	f/8	1/1000	800	n/a	n/a	18x10
38	Tree frog, Oregon	Nikon D700	Nikkor 100mm f/2.5 Macro	f/9.3	1/60	200	n/a	n/a	15x12
39	Old Highway 30, Columbia River Gorge	Nikon D2X	Nikkor 24mm f/2.0	f/8	1/80	200	n/a	n/a	15x12
40	Pheasant, Oregon	Nikon D500	Nikkor 200–500mm f/5.6	f/7.1	1/4000	2500	n/a	n/a	16x24
41	Middle North Falls, Silver Falls State Park, Oregon	Sony A7RII	Sony 55mm f/1.8	f/13	6″	64	21	2	58x33
42	North Falls, Silver Falls State Park, Oregon	Nikon D810	Zeiss 135 f/2.0	f/9.0	13″	64	9	1	117x39
44	National Forest Road 13, Mount Hood National Forest, Oregon	Nikon D810	Nikkor 35mm f/1.4	f/11	1/25	64	24	2	124x62
46	Hawk, Oregon	Nikon D500	Nikkor 200–500mm f/5.6	f/8	1/1600	720	n/a	n/a	24x16
47	Rasmussen Farm, O'Dell, Oregon	Nikon D600	Nikkor 85mm f/1.8	f/11	1/250	100	16	2	52x33
48	Mark O. Hatfield Wilderness, Oregon	Nikon D810	Nikkor 50mm f/1.4	f/13	1/6	64	6	1	70x31
50	Osprey, Oregon	Nikon D500	Nikkor 200–500mm f/5.6	f/6.3	1/4000	2200	n/a	n/a	36x36
51	Jackrabbit, Ankeny National Wildlife Refuge, Oregon	Nikon D500	Nikkor 200–500mm f/5.6	f/7.1	1/4000	1000	n/a	n/a	18x10
52	Railroad tracks near Eddyville, Oregon	Nikon D810	Zeiss 135mm f/2.0	f/13	1/5	64	30	2	121x36
54	White field and barn, Howell Price Road, Oregon	Nikon D810	Zeiss 135mm f/2.0	f/10	1/200	64	6	1	96x41
56	Coria Estates Vineyards, Oregon	Nikon D810	Nikkor 85mm f/1.8	f/11	1/40	64	9	1	57x20
58	Wooden Shoe Tulip Farm, Oregon	Nikon D800E	Nikkor 85mm f/1.8	f/14	1/50	100	6	1	48x25
60	Painted Hills, John Day Fossil Beds National Monument, Oregon	Nikon D600	Nikkor 85mm f/1.8	f/8	1/500	50	12	1	73x19
62	Blue Mountain Crest, Oregon	Nikon D810	Nikkor 50mm f/1.4	f/10	1/100	64	8	1	81x41
64	Trout meadow, Oregon	Nikon D810	Nikkor 50mm f/1.4	f/13	1/60	64	8	1	85x34
66	North Fork Wilderness from Blue Mountain, Oregon	Nikon D810	Zeiss 135mm f/2.0	f/9.3	1/80	64	7	1	92x39
68	Barn and horses along Oregon State Highway 203	Nikon D810	Nikkor 85mm f/1.8	f/8	1/200	64	5	1	77x30
70	Farm on Williams Road, Wilbur, Washington	Nikon D810	Nikkor 85mm f/1.8	f/13	1/80	64	13	1	79x20
72	Lone tree on Yellow Dog Road	Nikon D750	Nikkor 35mm f/1.4	f/4	1/320	100	12	1	66x15

74	Mustard field, Bob Schultz Road, Washington	Nikon D750	Nikkor 35mm f/1.4	f/11	1/80	100	9	1	79x36
76	Wind farm along Washington State Highway 12	Nikon D750	Nikkor 85mm f/1.8	f/10	1/80	100	10	1	72x19
78	Silos along Washington State Highway 28 [infrared]	Nikon D700 (IR)	Ziess 28mm f/2.0	f/11	1/250	200	10	1	56x24
80	Fence off Hay Road, Washington	Nikon D750	Nikkor 85mm f/1.8	f/11	1/250	100	8	1	48x19
82	Wayne and Linda's barn, Palouse Hills, Washington	Nikon D810	Nikkor 50mm f/1.4	f/14	1/25	80	6	1	54x29
84	Tractor along Washington State Highway 23	Nikon D810	Nikkor 85mm f/1.8	f/13	1/50	64	9	1	114x39
86	Hills along Getz–AE Seavers Road, Washington	Nikon D810	Zeiss 135mm f/2.0	f/13	1/50	64	8	1	59x20
88	Hoffman Road farm, Palouse Hills, Washington	Nikon D750	Nikkor 85mm f/1.8	f/11	1/250	100	7	1	81x37
90	Canola farm near Albion, Washington	Nikon D750	Nikkor 35mm f/1.4	f/11	1/250	100	12	1	48x21
92	Trees and hills near Elberton, Washington	Nikon D750	Nikkor 85mm f/1.8	f/10	1/640	250	8	1	53x19
94	Palouse Falls State Park, Washington	Nikon D750	Nikkor 85mm f/1.8	f/11	1/320	100	28	4	66x47
95	Cloud and wheat field, Seavers Road, Palouse Hills, Washington	Nikon D750	Nikkor 35mm f/1.4	f/11	1/200	100	18	2	49x33
96	Garfield County, Washington	Nikon D810	Nikkor 50mm f/1.4	f/13	1/500	250	12	1	60x20
98	Hello, horse! Washington State Highway 23.	Nikon D810	Nikkor 85mm f/1.8	f/10	1/320	64	8	1	48x30
99	Tipsoo Lake, Mount Rainier National Park, Washington	Nikon D810	Nikkor 50mm f/1.4	f/10	1/400	64	6	1	60x33
100	Toledo, Washington, and Bob 3	Nikon D800E	Nikkor 85mm f/1.8	f/10	1/125	100	11	1	89x19
102	Ohawapecosh River, Mount Rainier National Park, Washington	Nikon D800E	Zeiss 135mm f/2.0	f/13	1/15	100	21	3	50x44
103	Juvenile bald eagle, Washington	Nikon D7100	Nikkor 200–500mm f/5.6	f/8	1/1000	5000	n/a	n/a	48x42
104	Mount Rainier from Paradise, Washington	Nikon D800E	Zeiss 135mm f/2.0	f/13	1/320	100	22	2	82x29
106	Tunnel on Washington State Highway 123	Nikon D810	Nikkor 50mm f/1.4	f/11	1/125	64	8	1	50x21
108	Laughing Water Creek, Mount Rainier National Park, Washington	Nikon D810	Nikkor 200–500mm f/5.6	f/11	1.6"	64	n/a	n/a	48x42

109	Diablo Dam, Washington	Nikon E800E	Nikkor 85mm f/1.8	f/11	1/250	100	11	2	48x42
110	Giant leaves along Washington State Highway 410	Nikon D810	Nikkor 85mm f/1.8	f/10	1"	64	8	1	48x18
112	Canada jays, Mount Rainier National Park, Washington	Nikon D500	Nikkor 200–500mm f/5.6	f/5.6	1/2000	800	n/a	n/a	24x24
113	Elk, Goat Rocks Wilderness, Washington	Nikon D500	Nikkor 200–500mm f/5.6	f/5.6	1/2500	4500	n/a	n/a	24x24
114	Snoqualmie Pass, Washington	Nikon D810	Nikkor 85mm f/1.8	f/14	1/30	64	20	2	70x34
116	Olson Bluff along Coulee Meadows Road, Washington	Nikon D810	Nikkor 50mm f/1.4	f/9.0	1/160	64	18	2	116x48
118	Lake Chelan with apple orchards	Nikon D810	Nikkor 50mm f/1.4	f/10	1/1000	320	9	1	60x20
120	Apple orchard along Washington State Highway 17	Nikon D810	Nikkor 50mm f/1.4	f/11	1/100	54	9	1	46x19
122	The Little Red School House Fruit Stand, Naches, Washington	Nikon D810	Nikkor 50mm f/1.4	f/13	1/250	64	7	1	38x18
124	Apple crates on LaGrange Road, Washington	Nikon D810	Nikkor 85mm f/1.8	f/11	1/160	64	9	1	60x20
126	Apple orchard along Columbia River, Washington	Nikon D810	Nikkor 50mm f/1.4	f/11	1/125	64	10	1	52x19
128	Snow geese, Washington	Nikon D500	Nikkor 200–500mm f/5.6	f/5.6	1/2500	450	n/a	n/a	24x16
129	Snow geese near Wickersham, Washington	Nikon D500	Nikkor 200–500mm f/5.6	f/5.6	1/2500	560	n/a	n/a	24x16
130	Snake River, Washington	Nikon D750	Nikkor 85mm f/1.8	F/13	1/200	100	7	1	41x20
131	Mineral Train Museum, Washington	Nikon D800E	Nikkor 35mm f/1.4	f/11	1/60	10	8	1	31x19
132	Mineral Lake, Washington	Nikon D800E	Zeiss 135mm f/2.0	f/13	1/25	100	16	2	60x24
134	Old schoolhouse, Road J SE, Waterville, Washington	Nikon D810	Nikkor 50mm f/1.4	f/11	1/125	64	10	1	50x20
136	Fish Lake, Washington	Nikon D810	Zeiss 135mm f/2.0	f/11	1/200	64	9	1	67x19
138	Best Road, Skagit Valley, Washington	Nikon D800E	Zeiss 135mm f/2.0	f/9.0	1/1000	500	6	1	69x32
140	Tulips, Calhoun Road, Skagit Valley, Washington	Nikon D800E	Zeiss 135mm f/2.0	f/14	1/60	100	7	1	60x20

142	Barn along Washington State Highway 536	Nikon D800E	Zeiss 135mm f/2.0	f/9.0	1/100	160	5	1	48x28
143	Tulip field near Mossyrock, Washington	Nikon D750	Nikkor 85mm f/1.8	f/11	1/500	200	7	1	48x28
144	Ruby Beach, Washington	Nikon D800E	Zeiss 135mm f/2.0	f/13	1/80	100	14	2	50x42
145	Mayer Farms, Washington	Nikon D810	Nikkor 50mm f/1.4	f/11	1/160	64	8	2	50x42
146	Sunset, Deception Pass, Washington	Nikon D750	Nikkor 50mm f/1.4	f/11	1/100	100	7	1	48x31
147	Cape Disappointment North Head Light, Washington	Nikon D750	Nikkor 50mm f/1.4	f/11	1/250	200	16	2	48x31
148	Neah Bay Harbor, Washington	Nikon D750	Nikkor 85mm f/1.8	f/9.0	1/320	100	8	1	55x19
150	La Push Harbor at First Beach, Washington	Nikon D750	Nikkor 85mm f/1.8	f/10	1/40	100	16	2	41x16
152	Westport, Washington	Nikon D800E	Nikkor 85mm f/1.8	f/13	1/250	100	14	2	48x40
153	Elephant seal, Olympic Coast National Marine Sanctuary, Washington	Nikon D500	Nikkor 200–500mm f/5.6	f/9.0	1/1200	6400	n/a	n/a	48x40
154	Port Angeles, the *Orient Hope*	Nikon D800E	Zeiss 135mm f/2.0	f/10	1/250	100	8	1	96x28
156	Fort Casey Light, Washington	Nikon D800E	Nikkor 85mm f/1.8	f/9.0	1/1000	200	9	1	57x19
158	Nisika Beach, Oregon	Nikon D750	50mm f/1.4	f/9.0	1/100	100	9	1	72x33
160	Latourell Falls, Columbia Gorge National Scenic Area, Oregon	Nikon D600	Nikkor 35mm	f/1.4 f/16	1/160	50	13	3	50x42
161	Wild turkey, Oregon	Nikon D500	Nikkor 200–500mm	f/5.6 f/5.6	1/1000	800	n/a	n/a	24x16
162	North Camp Ground Trail, Silver Falls State Park, Oregon	Nikon D810	Nikkor 85mm f/1.8	f/11	1/6	64	8	1	89x37
164	Mount Hood and Trillium Lake, Oregon	Nikon D810	Nikkor 50mm	f/1.4 f/10	1/320	64	7	1	80x37
166	View from Sunrise Road at 6,100 feet, Mount Rainier National Park, Washington	Nikon D750	Nikon Zeiss 135mm	f/2.0 f/9.0	1/125	64	7	1	40x16
168	Mount Baker, Washington	Nikon D800E	Nikkor 85mm	f/1.8 f/11	1/200	100	8	1	58x20
170	Lake Quinault, Washington	Nikon D800E	Nikkor 50mm	f/11	1/250	100	10	1	74x35